Carolyn Lanchner

Henri Matisse

The Museum of Modern Art, New York

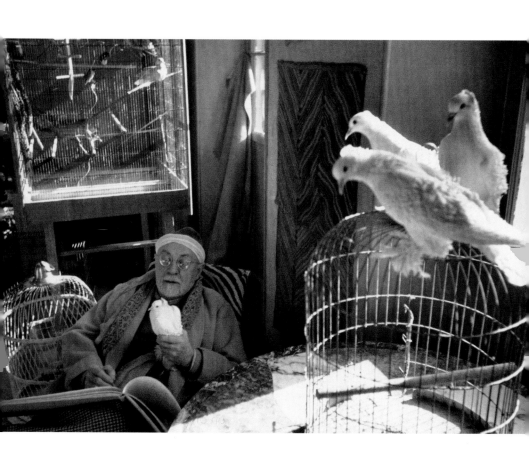

Henri Cartier-Bresson (French, 1908–2004)
Henri Matisse, Vence, France 1944
Gelatin silver print, 9 $^{7}/_{16}$ x 13 $^{7}/_{8}$" (24 x 35.3 cm)
The Museum of Modern Art, New York
Gift of the photographer, 1964

This book presents eleven works selected from the almost 1,100 pieces by Henri Matisse in the collection of The Museum of Modern Art. In 1931 the Museum made Matisse's work the subject of its first loan exhibition devoted to a European artist. A year later MoMA acquired twelve lithographs by Matisse, the first works by the artist to enter the collection. *The Piano Lesson* (discussed here on page 23) joined several other paintings, one sculpture, and many works on paper by Matisse in the collection in 1946. It was followed in 1949 by *The Red Studio* (page 11). In 1951 the Museum hosted a major loan exhibition of Matisse's oeuvre; at that time it had around thirty-five works by the artist in its collection. *The Drawings of Henri Matisse* (1984–85) and *Matisse in Morocco* (1990) followed, both collaborations with other institutions. By 1992, when the Museum mounted *Henri Matisse: A Retrospective*, its collection of the artist's work had grown to just over 1,000. In the catalogue accompanying the retrospective, curator John Elderfield declares that "Matisse's absolutely central importance to the evolution of modern art cannot be overstated." This book is one in a series featuring artists represented in depth in the Museum's collection.

La Japonaise: Woman Beside the Water 1905
Oil and pencil on canvas, 13 ⁷/₈ x 11 ¹/₈"
(35.2 x 28.2 cm)
The Museum of Modern Art, New York
Purchase and anonymous gift, 1983

La Japonaise: Woman Beside the Water (1905)

Henri Matisse spent the summer of 1905 working alongside the artist André Derain in the small Mediterranean seaport of Collioure [fig. 1]. The paintings they produced there and exhibited in Paris in the fall gave Matisse and his associates a name: *les fauves*, or "the wild beasts." This enduringly misleading term was later clarified by Matisse. Fauvism was, he said, construction by means of color and, as such, was the source of everything that followed in his art.

This painting from that foundational summer shows Matisse's wife, Amélie, in a Japanese gown sitting beside the ocean at Collioure. Although its title proposes Mme Matisse as subject, the fluid reciprocity of figure and ground is such that the ostensible protagonist dissolves into the surrounding seascape. The horizontal brushstrokes at the upper left are liberated holdovers from Neo-Impressionism, but, for the most part, the picture fuses the processes of painting and drawing in spontaneous curls and strips of equivalently intense reds and greens and

5

1 André Derain (French, 1880–1954)
Matisse and His Wife at Collioure 1905
Pen and ink on paper, 11 $^7/_8$ x 18 $^7/_8$"
(30.2 x 47.9 cm)
The Metropolitan Museum of Art
Hermina, Movses, Charles, and David Allen
Devrishian Fund, 2004

other equally matched contrasting hues. Laid down with staccato-like gestures on the white surface of the canvas, they create the vibrant, flickering effects of bright sunlight. Later, as a teacher Matisse distinguished two ways of painting—one in which color is considered as warm or cool and another that "seeks light through the opposition of colors." As painter and art historian Lawrence Gowing pointed out, "The latter was Matisse's way and he pursued it almost without interruption for the rest of his life, placing color against color and revealing an inherent light in the interval and the interplay between them."

Dance (I) (1909) In 1908 Matisse wrote,

"A work of art must carry in itself its complete significance and impose it upon the beholder even before he can identify the subject matter." This monumental image of elemental joy and energy strikingly exemplifies its author's self-injunction, and it so forcibly impressed the Moscow collector Sergei Shchukin that he commissioned a second version, *Dance (II)* [fig. 2], now in the State Hermitage Museum, St. Petersburg. Nearly identical in composition to *Dance (I)*, *Dance (II)* was shown in Paris in 1910. Observers were mostly critical, reacting to its willfully crude simplifications of the human body and the lack of perspective and foreshortening that made nearer and further figures equal in size and the sky an uninflected blue plane. One commentator, however, found that such aesthetic barbarism "assisted the primitive . . . one might almost say rudimentary

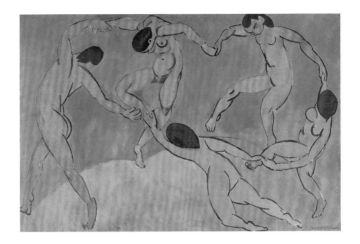

expression of the whole. For the rhythms of these dancing figures are those of instinct and nature."

While Matisse's conception of the subject of dance is an ancient one, the closest source for the two canvases is the ring of dancers in the background of his 1905–06 Arcadian composition *Joy of Life* [fig. 3]. But the less-than-sedate rhythms of the later dancing figures were, according to Matisse, partially inspired by watching the clientele at the Moulin de la Galette, in Montmartre, Paris, doing the farandole. In *Dance (II)* the figures are more sinewy and energetically controlled than in *Dance (I)*, where they appear more amateurish, perhaps closer to the local Montmartre performance style. In the latter the dancer at the left moves with realized intent, her body an unbroken contour from rear foot to breast. Thereafter, purpose seems to yield to enthusiasm; her companions alternately jig, jump, kick, and stumble. The last, particularly, gives it her all as her arm literally stretches to hold the hand of the kicking figure to her right. Seemingly on the verge of falling, she breaks the circle in a failed attempt to clutch the leader's hand. Matisse simultaneously dramatizes and

7

2 *Dance (II)* 1909–10
Oil on canvas, 8' 5 ⅝" x 12' 9 ½"
(260 x 391 cm)
The State Hermitage Museum,
St. Petersburg. Formerly collection
Sergei Shchukin

Pages 8 and 9 *Dance (I)* 1909
Oil on canvas, 8' 6 ½" x 12' 9 ½"
(259.7 x 390.1 cm)
The Museum of Modern Art, New York
Gift of Nelson A. Rockefeller in honor of
Alfred H. Barr, Jr., 1963

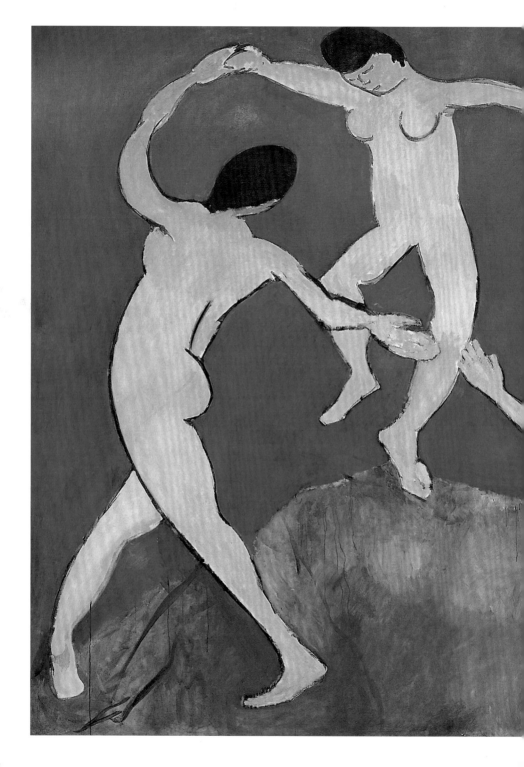

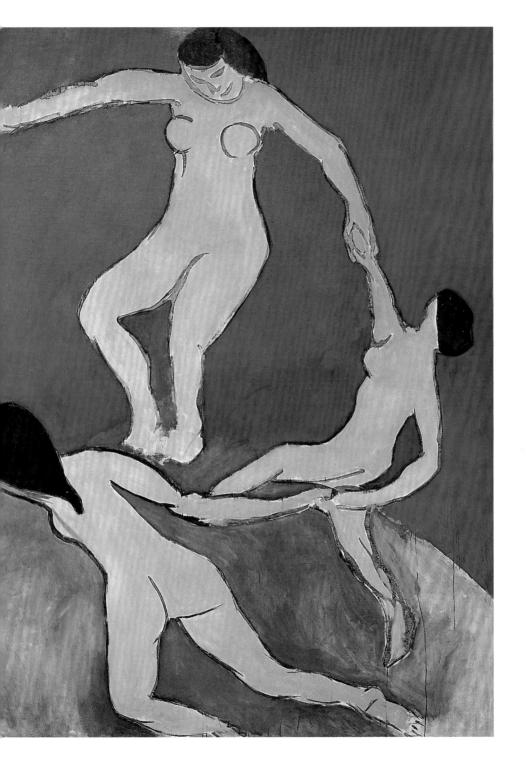

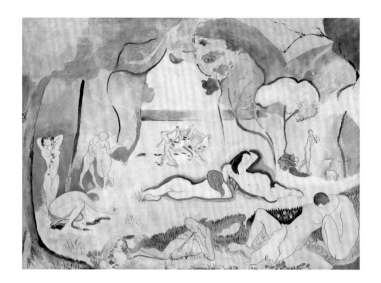

conceals this incident. The indistinct outline and smudged paint of the left figure's extended hand mimics the visual blur of speed and, contrasting with the articulated fingers reaching toward it, heightens the tension of the moment. But caught in the painting's exuberant whirl, the viewer may not focus on the imminent break in momentum. The pink knee of the jigging dancer at the upper left fills the gap between outstretched hands.

Matisse acknowledged that the dominant colors of *Dance (I)* were derived from observation—the green pines and blue sky of southern France and the pink of flesh. They were not, however, meant to be specifically descriptive; what was important was the expressive combination. He explained, "When I put down a green, that doesn't signify grass; when I put a blue, that doesn't mean sky. . . . All my colors sing together, like a chord in music."

3 *Joy of Life* 1905–06
Oil on canvas, 69 $^1/_8$" x 8' 1 $^7/_8$" (175 x 241 cm)
The Barnes Foundation, Merion Station,
Pennsylvania. Formerly collections
Leo Stein, Christian Tetzen-Lund

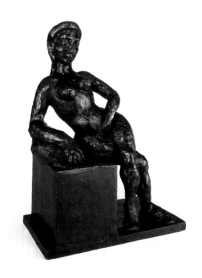

The Red Studio (1911) Matisse

once said that he wanted color to be "conclusively present" in his paintings. In this radiant view of the artist's white-walled studio, it floods almost everything. Submerged in a continuum of Pompeian red, space and furniture merge, the contours of the latter diagrammatically indicated in pale yellow. Vibrant against the vivid monochrome ground, Matisse's paintings and sculptures in near-true color and miniature scale are clustered around the off-center vertical of a grandfather clock without hands. Some important earlier works Matisse rendered here are the bronze *Decorative Figure* and the paintings *The Young Sailor (II)* and *Le Luxe (II)* [figs. 5 to 7].

The expanse of red that contains this carefully arranged exhibition of the artist's work is largely responsible for modernist art critic Clement Greenberg's dictum that *The Red Studio* was "perhaps the flattest painting done anywhere up to that time." Matisse's use of the engulfing red field as iteration of the canvas's

5 *Decorative Figure* 1908
Cast by C. Valsuani c. 1946–51
Bronze, 28 $^3/_8$ x 20 $^1/_4$ x 12 $^1/_4$"
(72.1 x 51.4 x 31.1 cm)
The Hirshhorn Museum and Sculpture Garden, Smithsonian Institution, Washington, D.C. Gift of Joseph H. Hirshhorn, 1966

The Red Studio 1911
Oil on canvas, 71 $^1/_4$" x 7' 2 $^1/_4$"
(181 x 219.1 cm)
The Museum of Modern Art, New York
Mrs. Simon Guggenheim Fund, 1949

planarity was surely part of his personal ambition to find "a larger and truly plastic space." While *The Red Studio* definitively dispenses with traditional three-dimensional illusionism, ghosts of linear perspective remain. A thin line representing orthogonal recession defines the left corner of the room, angling "behind" the large vertical painting of a nude to demarcate the juncture of wall and floor. The omission of a vertical line to indicate convergence of side wall and back wall should add to the flattening effect of the allover red, but any such result is compromised by the way the pink painting leans into the invisible corner while, next to it, stacked canvases tilt backward. In another variant of spatial hijinx, this assertively frontal studio view is painted as though the visitor were looking down on it. Although Matisse absented himself from this *atelier* tour, an open box of crayons on the foreground table suggests his presence.

13

6 *The Young Sailor (II)* 1906
Oil on canvas, 40 x 32 ³/₄" (101.5 x 83 cm)
The Metropolitan Museum of Art. Jacques
and Natasha Gelman Collection, 1998
Formerly collection Leigh B. Block

7 *Le Luxe (II)* 1907–08
Oil on canvas, 6' 10 ¹/₂" x 54 ³/₄"
(209.5 x 140 cm)
Statens Museum for Kunst, Copenhagen

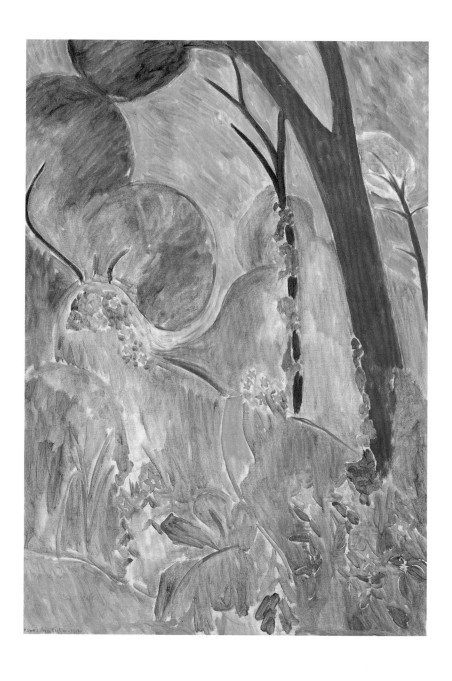

Periwinkles/Moroccan Garden (1912)

This painting is one of a triad of landscapes [with figs. 8 and 9] that Matisse painted in the secluded, luxuriant gardens of the Villa Brooks during his first trip to Tangier, in early 1912. Although his visit was made at a moment of acute political instability, Matisse found the "landscapes of Morocco just as they had been described in the paintings of Delacroix and in the novels of Pierre Loti." The latter's painterly evocation of the unfolding of an African spring—"Everything turned green, as if an enchantment lay upon the earth; little patches of moist warm shade fell from the leafy trees to the humid ground . . . and drifting over everything waves of hot and scented air"—is poetically transcribed in the aerated surfaces of *Periwinkles/Moroccan Garden*. The salmon-pink sky, gray foliage, lime-green leaves, and turquoise earth seem to swell like expanding ether. Drifting here and there are the pale-blue peri-

15

Periwinkles/Moroccan Garden 1912
Oil, pencil, and charcoal on canvas,
46 x 32 ¹/₂" (116.8 x 82.5 cm)
The Museum of Modern Art, New York
Gift of Florene M. Schoenborn, 1985

8 *Moroccan Landscape (Acanthus)* 1912
Oil on canvas, 45 ¹/₄ x 31 ¹/₂" (115 x 80 cm)
Moderna Museet, Stockholm

9 *Palm Leaf, Tangier* 1912
Oil on canvas, 46 ¹/₄ x 32 ¹/₄" (117.5 x 81.9 cm)
National Gallery of Art, Washington, D.C.
Chester Dale Fund

winkles of the picture's title. Less anchoring the composition than contributing hints of Art Nouveau decor and a sense of gentle flux are the three tree trunks to the right.

The painting's scumbled layers of thin, transparent pigment seem to have been applied with great spontaneity, yet the free handling covers a layout meticulously drawn in pencil. Very carefully following the outlines, Matisse allowed his brush virtually no freedom to deviate from the inscribed design. At the time, he found such disciplined planning a means by which to create the sort of pictorial harmony and calm that reigns in this vision of a timeless exotic paradise.

Goldfish and Palette (1914)

Matisse sketched out his plans for this painting on a postcard he sent to the painter Charles Camoin, explaining, "I'm redoing my picture of a goldfish with a person in it who holds a palette in his hand and who is observing." His reference is to *Interior with a Goldfish Bowl* [fig. 10], painted some months previous, the most recent in a series of five canvases featuring goldfish. Setting the scene for its successor, it shows the corner of Matisse's quai Saint-Michel studio, with its small table supporting a goldfish bowl and a potted plant against the scrolling grillwork of a window open to a view of the Seine and the Île de la Cité beyond.

This essentially domestic contemplation of interior and exterior was radically reconceived in *Goldfish and Palette*. Intervening between the pictures were two key experiences. One

Goldfish and Palette 1914
Oil on canvas, 57 $^3/_4$ x 44 $^1/_4$"
(146.5 x 112.4 cm)
The Museum of Modern Art, New York
Gift and bequest of Florene M. Schoenborn
and Samuel A. Marx, 1964

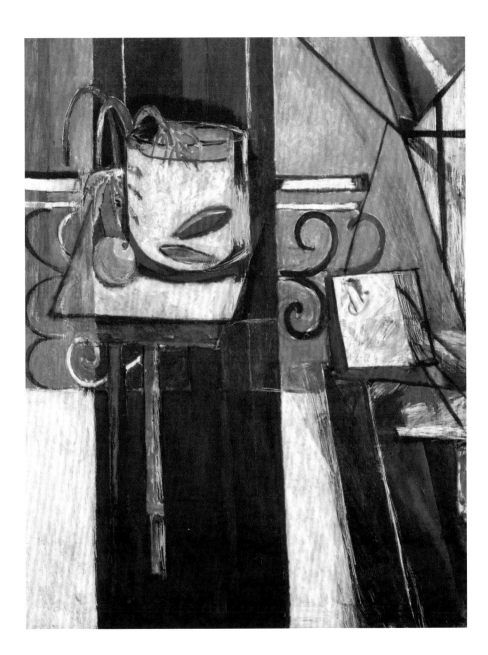

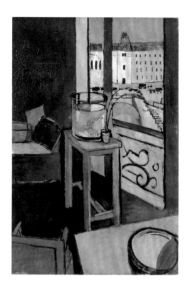 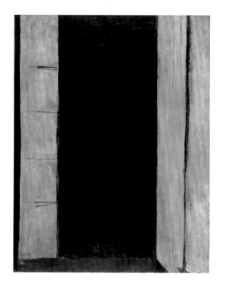

was the advent of World War I, commemorated by Matisse in the autumn of 1914 by what Kirk Varnedoe described as the "bottomlessly bleak" *French Window at Collioure* [fig. 11]. The other was his increasing engagement with Cubism, a development often linked to his then frequent contact with the artist Juan Gris. The upright banding of *Goldfish and Palette* has sometimes been attributed to their association, although it might equally have been suggested by the collages of Georges Braque and Pablo Picasso. The more immediate influence of Gris may be reflected in the decoratively abstract triangle at the upper left. The painting's dominant structural element, the massive black vertical in the center, is, however, far more a reiteration of the dense, opaque rectangle implacably occupying the middle of *French Window at Collioure* than it is a replay of Cubist practice. But to whatever extent that black shaft of palpable shadow may have been derived from a creative misreading of Cubism, a year later, when Matisse saw and deeply admired Picasso's *Harlequin* [fig. 12], he read its composition as an inspired manipulation of his own.

18

10 *Interior with a Goldfish Bowl* 1914
Oil on canvas, 57 ⁷/₈ x 38 ¹/₈" (147 x 97 cm)
Musée National d'Art Moderne, Centre
Georges Pompidou, Paris

11 *French Window at Collioure* 1914
Oil on canvas, 45 ⁷/₈ x 35" (116.5 x 89 cm)
Musée National d'Art Moderne, Centre
Georges Pompidou, Paris

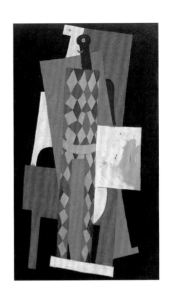

While *Goldfish and Palette* demonstrates a sophisticated and selective give-and-take with Cubism, it is invested with an intensity of feeling unusual to that more rarified style. John Elderfield has pointed out that the painting is "anti-Cubist in the sense of light it provides." The otherwise forbidding dark band is warmed by soft greens and mauves in the table's scraped-over legs. And above, within its borders, "the rich orange-and-yellow fruit and especially the red-and-magenta goldfish radiate a brilliant light that seems to infuse the scumbled white of the table-top and milky water of the aquarium." This enclosed, luminously serene still life stands in stark and poignant contrast to the cold, severe world surrounding it.

The still life has, of course, an observer. To the middle right the artist's thumb emerges through a white rectangular palette in ghostly apposition to the shapes of the goldfish within the bowl's rectangular plane. Lost in the surrounding heavily reworked area is the artist's figure: The person who "holds a palette

19

12 Pablo Picasso (Spanish, 1881–1973)
Harlequin 1915
Oil on canvas, 6' 1/4" x 41 3/8" (183.5 x 105.1 cm)
The Museum of Modern Art, New York
Acquired through the Lillie P. Bliss Bequest, 1950

in his hand and who is observing." Materialized in the picture is the concentrated force of Matisse's private, fixated observation. A decade after it was painted, French Surrealist André Breton proclaimed that *Goldfish and Palette* had "everything, formal innovation, profound penetration of every object by the artist's own life, magical colors. . . . I'm convinced Matisse has never put so much of himself into any other painting."

The Moroccans (1915–16)

This severe, seductive painting is based on Matisse's memories of "the terrace and little café of the Casbah" in Tangier, Morocco, where he had spent the winters of 1912 and 1913. When he began the picture some two years after his second visit, he told a friend, "The problem is to dominate reality," a process he explained as the elimination of every element that would not contribute to the work's rhythm and balance. He so unsparingly emptied his canvas of the inessential that a constant, reciprocal interplay between the representational and the abstract is enacted in the finished work.

Structurally, the picture divides into three sections. Alfred H. Barr, Jr., founding director of The Museum of Modern Art, designated the upper-left area as "the architectural section," showing a balcony with flowerpot, the dome of a mosque, and a trelliswork roof; below is the "still-life section," displaying four yellow melons with green leaves on a tiled pavement. In the "figures section," a Moroccan man sits with his back to the viewer. To his right is

The Moroccans 1915–16
Oil on canvas, 71 ³/₈" x 9' 2"
(181.3 x 279.4 cm)
The Museum of Modern Art, New York
Gift of Mr. and Mrs. Samuel A. Marx, 1955

an arched doorway and, above, windows with vestigial figures. The form to his left is the most ambiguous; it has been read as a man's burnoose and circular turban. The composition's diagrammatic partitioning and pared-down, almost abstract shapes are enriched by the formal analogies that cross its internal borders. Among other visually confounded identities are the striped flowers of the architecture section, the yellow melons below, and the head of the seated man. The construction of the latter's figure suggests another view of the architecture to his left.

Enveloping two-thirds of the picture is, in Matisse's words, "a grand black . . . as luminous as the other colors in the painting." Ingeniously contrived, the black and the adjacent lavender seem of equal brilliance and together evoke a sense of physical heat, of the intensity of sun and shadow in northern Africa. The dominant black also serves, Matisse noted, as a "force to simplify the composition." At once uniting and separating the three sections of the composition, its dense expanse was, according to the artist, "the beginning of my expression with color, with blacks and their contrasts."

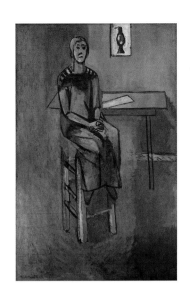

The Piano Lesson (1916)

The little boy so earnestly playing the piano looks anxious, as though he wishes to be elsewhere. He is Pierre Matisse, the artist's younger son, who later confirmed how uneasily he endured his enforced music lessons. Here he is monitored by two women. Behind him sits an angular, rigidly attentive person whose featureless white face is a mask of concentration, and beside him, at the extreme left corner of the painting, a small, voluptuous nude turns her head toward him. Both, however, are inanimate sentries. They are a bronze, *Decorative Figure* [fig. 5], and a painting, *Woman on a High Stool (Germaine Raynal)* [fig. 13], made by Matisse *père* and decorating the family living room. Presumably more actively engaged in the surveillance process is the gray metronome directly in front of the practicing child. Its form is reflected in a wedgelike shadow over his right eye that obviates any chance of a distracting glimpse of its visual echo, the great green slice of forbidden garden beyond the window. 23

13 *Woman on a High Stool (Germaine Raynal)* 1914
Oil on canvas, 57 $^7/_8$ x 37 $^5/_8$" (147 x 95.5 cm)
The Museum of Modern Art, New York
Gift and bequest of Florene M. Schoenborn and Samuel A. Marx, 1964

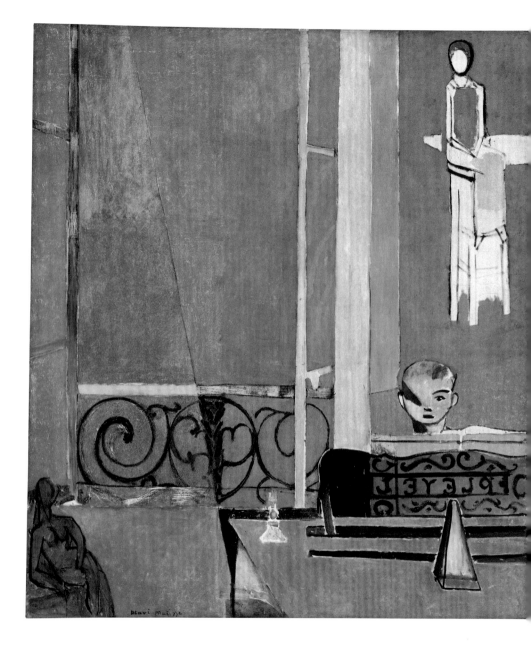

The Piano Lesson 1916
Oil on canvas, 8' ¹/₂" x 6' 11 ³/₄" (245.1 x 212.7 cm)
The Museum of Modern Art, New York
Mrs. Simon Guggenheim Fund, 1946

As a revelatory moment in the musical education of his son, this painting belongs to the genre of Matisse family pictures, but its larger emphasis is on art and its making, and as such it relates to the artist's studio pictures containing representations of his own work. Meshing personal symbolism with the most disciplined formal control, the painting hovers close to abstraction. The tilted pink top of the piano and its music stand are the only props unequivocally proposing a setting. The air of interior and exterior and the tangible canvas of *Woman on a High Stool* are equally represented by an anonymous, enveloping gray flattening and expanding pictorial space. Aside from the corner in which Pierre practices, the gray is interrupted only by a suave, measured geometry that articulates the architectural coordinates of the Matisses' living room. Making the slightest of detours to accommodate the pianist's head, an ocher band rises in gentle chromatic contrast against a longer pale-blue vertical to indicate the receding side wall of the room. In the same blue, slightly to the left, a long, thin line represents the frame of the open French window. This stepwise progression from spatially retreating wall to open window makes visible what traditional perspective would hide. Here Matisse took the torqued space of Cubism, refined it of incident, and made it architectural. Farther left, the triangular sweep of greensward appearing miragelike from the gray tempers the picture's rectilinear geometry and, almost edge-to-edge with the pink piano, "creates a valuable moment of excitement in an otherwise disciplined calm," Alfred H. Barr, Jr., wrote. Running over the green of the grass and the ambient gray, the balcony's black scrollwork meets the filigree curves of the music stand in a visual version of music's curling notes. The painting, as Matisse's biographer Hilary Spurling has observed, is "like a Bach concerto, at once measured, harmonious, and steeped in feeling."

The Back (III) (1916) "Fit your parts
into one another and build up your figure as a carpenter does
a house. Everything must be constructed—built up of parts
that make a unit; a tree like a human body, a human body like
a cathedral." This advice Matisse delivered to his students
is almost literally exemplified in *The Back (III)* and is opera-
tive in the progression from a stylized naturalism to an archi-
tectonic concision in the group of four sculptures to which
it belongs. Made at widely spaced intervals over the years
between 1908 and 1931, the Backs were not conceived as a
series. Nonetheless, these, the largest of Matisse's sculptures,
not only present a coherent development but, as reliefs, are
unique in sharing with some of his grand paintings the ambi-
tious, monumental look of public art.

 This, the third in the series, is more undeviatingly vertical
than its predecessors. In the first, *The Back (I)* [figs. 14 and 16],
the spine is "an assertive linear stem off which spring branches"

26

14 *Standing Woman Seen from Behind*
(Study for *The Back [I]*) 1909
Ink on paper, 10 ¹/₂ x 8 ⁵/₈" (26.6 x 21.9 cm)
The Museum of Modern Art, New York
Carol Buttenweiser Loeb Memorial Fund,
1969

15 Study for *The Back (II)* c. 1913
Ink on lined paper, 7 ⁷/₈" x 6 ¹/₄"
(20 x 15.7 cm)
The Museum of Modern Art, New York
Gift of Pierre Matisse, 1971

The Back (III) 1916
Bronze, 6' 2 ¹/₂" x 44" x 6"
(189.2 x 112.4 x 15.2 cm)
The Museum of Modern Art, New York
Mrs. Simon Guggenheim Fund, 1952

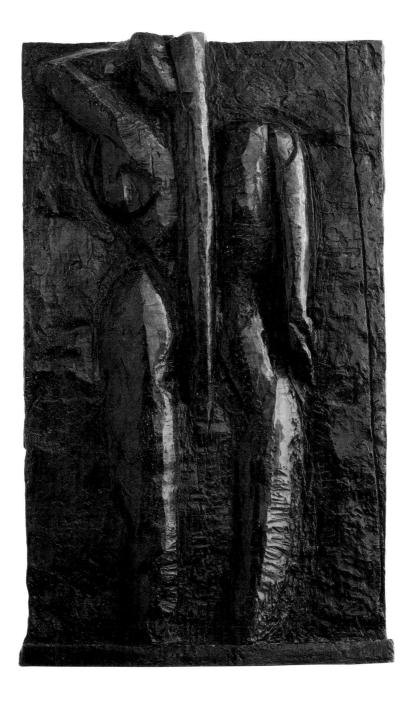

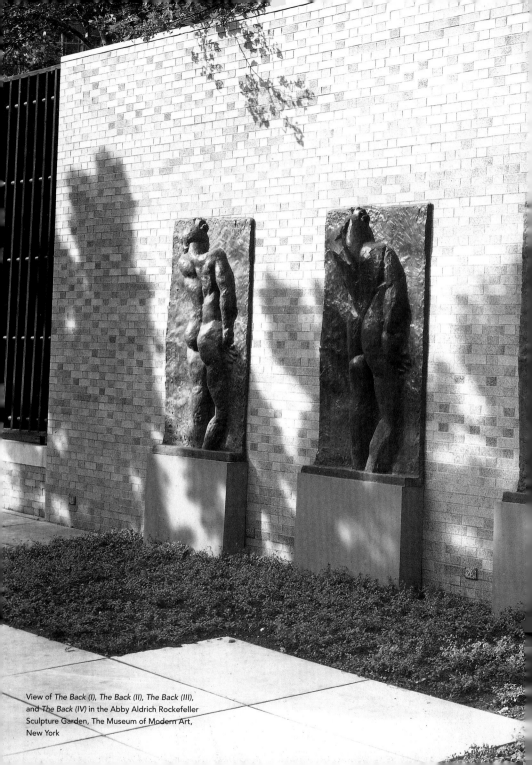

View of *The Back (I)*, *The Back (II)*, *The Back (III)*, and *The Back (IV)* in the Abby Aldrich Rockefeller Sculpture Garden, The Museum of Modern Art, New York

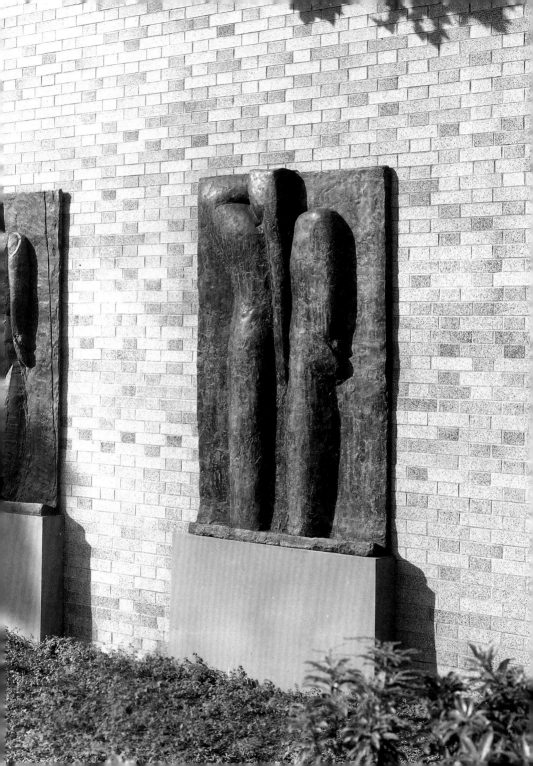

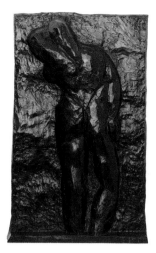
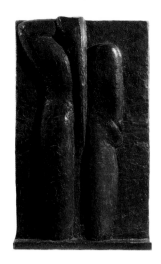

defining fleshy areas of the back, John Elderfield has written. A deeply incised arabesque winds up from the relaxed right leg to the bent left arm. In *The Back (II)* [figs. 15 and 17] the spinal crevice has been filled in and the spine itself aligned with the inner contour of the left leg. Any hint of the first figure's arabesque has been almost entirely eradicated, producing, in Elderfield's words, a "Cubist giant, coarsely chiseled and abraded, slumbering against a wall." With *The Back (III)* comes the most startling transformation of the series. The spine, in high relief, elongated, and utterly straight, has become a column of hair descending from the head—now above the top of the sculpture's back plane—to the thighs of the now trunklike legs. Plummeting through the composition, the hair's long rigid fall "functions as the fulcrum around which the other forms are balanced." Although it was made in 1931, some fifteen years later, the final relief [fig. 18] completes its predecessors' moves toward simplified monumental structure. The reduction of the figure to three uninflected vertical zones, together with its larger occupation of ground and homogeneous

30

treatment of surface, create a nearly symmetrical architectural harmony. Commenting on the four reliefs, Matisse's eldest grandson said, "If you let yourself respond fully to them you will find in them the whole life of Henri Matisse; an extraordinary equilibrium, returning always to the plumb line."

Odalisque with a Tambourine (1925–26)

Beginning in 1917 Matisse lived a large part of every year in Nice or its environs. His first span of years there, through the 1920s, in which he produced paintings filled with languorous, seductive models in highly decorated interiors, is usually known as his Nice period. This picture of a full-length nude curled into a striped armchair in a room luminous with Mediterranean light, her status as *odalisque* confirmed by the red-rimmed tambourine at the upper right, seems to fit the period's typology. But the model, Henriette Darricarrère, Matisse's studio assistant and favorite sitter, has a tactile presence unusual for the time. The tense, self-contained pose she holds is invigorated and intensified by the painting's heavily worked, impastoed surface; the clay-colored paint of her body is densely applied, as if with a sculptor's knife. Overall, the interlocking slabs of paint modeling the surface form a picture at once recognizable and verging on the abstract.

Not by chance, this new emphasis on pictorial mass coincided with the beginnings of one of Matisse's most important sculptures, *Large Seated Nude* [p. 35]. Both canvas and sculpture

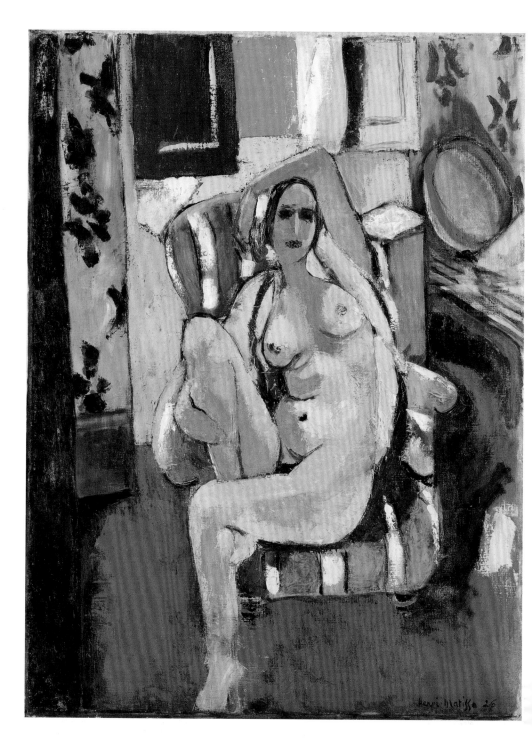

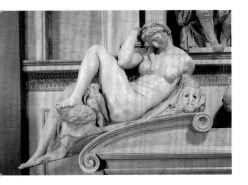
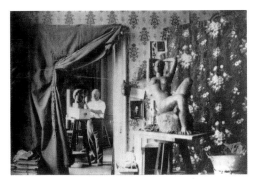

focus on a long, physically resilient figure whose pose was derived from a cast of *Night*, a detail from Michelangelo's *Tomb of Giuliano, Duke of Nemours* [fig. 19] that Matisse had been drawing from for the past several years. Indeed, it is reported by Hilary Spurling that in the spring of 1922 Matisse "spent mornings painting Henriette and afternoons drawing *Night*," making, the artist said, "real progress in my study of form, and I hope that tomorrow my painting will feel the benefit." We know from photographs of Matisse's studio [such as fig. 20] that this particular *odalisque* hung on his wall during the drawn-out process of refining and reworking *Large Seated Nude*.

dalisque with a Tambourine 1925–26
il on canvas, 29 ¹/₄ x 21 ⁷/₈" (74.3 x 55.6 cm)
ᴉe Museum of Modern Art, New York
ᴉe William S. Paley Collection, 1990

19 Michelangelo di Lodovico Buonarroti Simoni (Italian, 1475–1564)
Tomb of Giuliano, Duke of Nemours (detail: *Night*)
Florence, Medici Chapels

20 Matisse in his studio at 1 place Charles-Félix, Nice, spring 1926. *Odalisque with a Tambourine* is on the wall behind *Large Seated Nude*. Photographic Archive, The Museum of Modern Art Archives, New York

Large Seated Nude (1925–29)

Shortly after moving to Nice in 1917, Matisse began to draw from a plaster cast of *Night*, a detail from Michelangelo's *Tomb of Giuliano, Duke of Nemours* [fig. 19]. "I try to assimilate the clear and complex conception of Michelangelo's construction," he explained to a friend. The pose of *Large Seated Nude* was derived, with detours and modifications, from *Night*. The process of "assimilation" that produced this grand, athletically seated nude—the artist's largest fully three-dimensional sculpture—was protracted, intermittently occupying him from 1925 through 1929. Hilary Spurling reports that Matisse came to see himself "as a kind of Pygmalion in reverse, enslaved by a statue whose living will dominated its creator. Every year he fetched a skilled workman from Marseilles to mold his statue in plaster . . . hoping to finish it . . . and every year it defeated him." From photographs of the work in progress, we know that Matisse gradually increased its size, elongated the torso, and cantilevered the body into space, lowering the angle of elongation. He also replaced soft volumes with tighter, more muscular, even masculine planes and, omitting the hair, reduced the head to a hard cranial shape. In the figure's final state its finely calibrated equilibrium crucially relies on a balancing device only a little less essential to steadying the nude in *Odalisque with a Tambourine* [p. 32]—a foot hooked into the crook of the opposite knee. Thematically and chronologically of a piece with his Nice period paintings of lounging *odalisques*, this sculpture transforms those decorative figures into a monumentality that, more than anything else, provided the direction for the shifting course of Matisse's art in the second half of the 1920s.

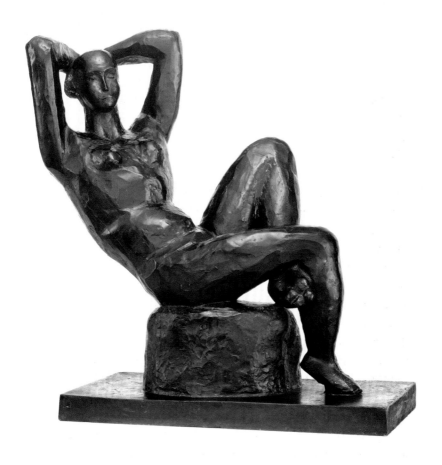

Large Seated Nude 1925–29
Bronze, 31 $^1/_4$ x 30 $^1/_2$ x 13 $^3/_4$"
(79.4 x 77.5 x 34.9 cm)
The Museum of Modern Art, New York
Gift of Mr. and Mrs. Walter Hochschild
(by exchange), 1987

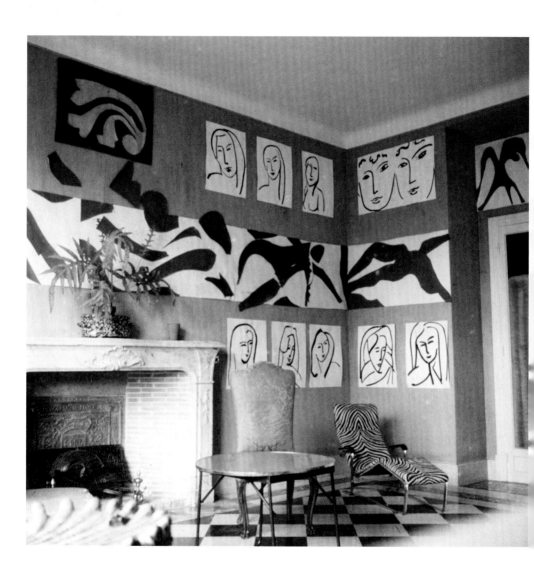

21 *The Swimming Pool* surrounded by
brush-and-ink drawings in the dining room
of Matisse's apartment in the Hôtel Régina,
Nice-Cimiez, France, c. 1952

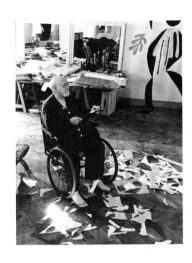

The Swimming Pool (1952)

Matisse assembled this exuberant aquatic ballet for his own pleasure. By far the largest of his cutouts, at fifty-four feet long and over seven feet high it stretched across the walls of his dining room at the Hôtel Régina in Nice [fig. 21], where he lived the last few, extraordinarily productive years of his life. Confined to a wheelchair, the eighty-two-year-old artist found special ease in his great blue-and-white frieze, saying, "I have always adored the sea, and now that I can no longer go for a swim, I have surrounded myself with it."

However surveyed, the extended band begins and ends with a stylized starfish. The starfish at the far end of the section that was to the right of Matisse's dining room door is of springy step but in no great hurry. The other is sprinting as if propelled by accumulated momentum. Interpreting these contrasting attitudes as a directional cue to scroll across the panels of leaping, cavorting, sprawling bathers and assorted marine life from the less active to the more active starfish, we gradually encounter a fluid

37

22 Matisse at work on a paper cutout in his studio in the Hôtel Régina, Nice-Cimiez, France, early 1952. Photographic Archive, The Museum of Modern Art Archives, New York

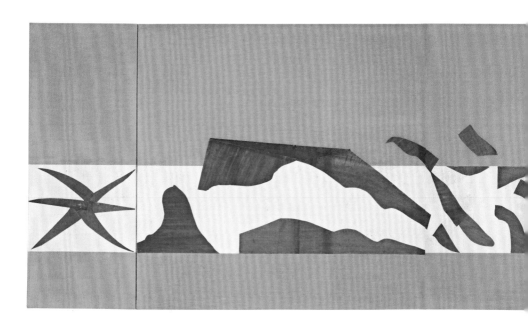

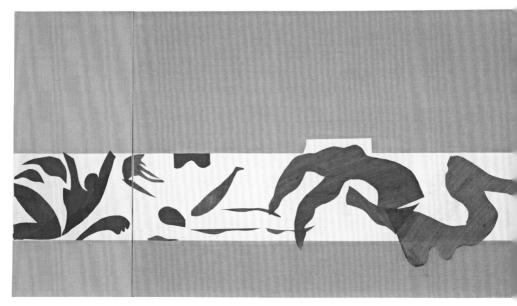

The Swimming Pool 1952
Nine-panel mural in two parts: gouache on
paper, cut and pasted, on white-painted
paper mounted on burlap, a–e: 7' 6 ⁵/₈" x

27' 9 ¹/₂" (230.1 x 847.8 cm), f–i: 7' 6 ⁵/₈" x
26' 1 ¹/₂" (230.1 x 796.1 cm)
The Museum of Modern Art, New York
Mrs. Bernard F. Gimbel Fund, 1975

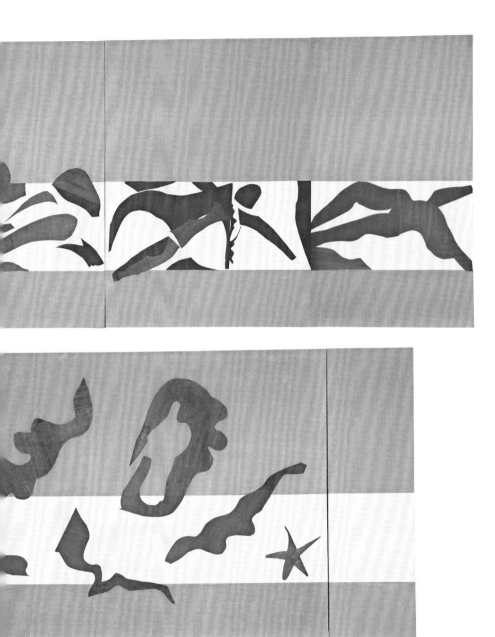

deviation in their development. Initially, the quasi-abstract blue shapes are sharply delineated against the painted white paper ground or leap from it, like splashing water, assertively silhouetted by the burlap that now simulates the effect of the walls of Matisse's dining room. This pattern persists with some irregularities until the panel preceeding the penultimate, where, with no decrease in high definition, the intermingling of blue forms and white ground produces no cohesive whole. If, as has been suggested, a figure executing a butterfly stroke can be intuited from the panel's rhythmically interacting areas of blue and white, it can only be a swimmer whose substance is interchangeable with the element in which he or she swims. In the next full panel Matisse reverted to an emphatic affirmation of dominating shape, but he inverted his methods. Carving blue shapes to create the white body of the last, most abstract, and largest bather, he definitively quashed any expectations of stable relations between form and field. This slippery volatility between figure and ground, swimmers and pool, brings to the work a sense of intense physical exhilaration, like an athlete's experience in "the zone." Sensations of bodily transcendence are amplified by shifting viewing angles, at times given from above, as though looking down into the water, at others as if from within the water.

In making this joyous, high-spirited composition Matisse overcame limitations peculiar to his trade. Although his use of the cutout technique in his last years was essentially a response to frail health, it was also an answer to "the eternal conflict of drawing and color." He explained, "Cutting colored papers permits me to draw in color—guarantees a precise union of the two

properties." In 1952, when he decorated his dining room with this, the grandest ever of his recurring idealized, golden-age images, he was aware of it as a culmination: "There is no break between my painting and my cutouts. Only, with something more of the abstract and the absolute, I have arrived at a distillation of form. . . . I have preserved the sign which is sufficient and necessary to make the object exist in its own form and in the totality for which I conceived it."

View of the exhibition *Henri Matisse: A Retrospective*, The Museum of Modern Art, New York, 1992. Photographic Archive, The Museum of Modern Art Archives, New York

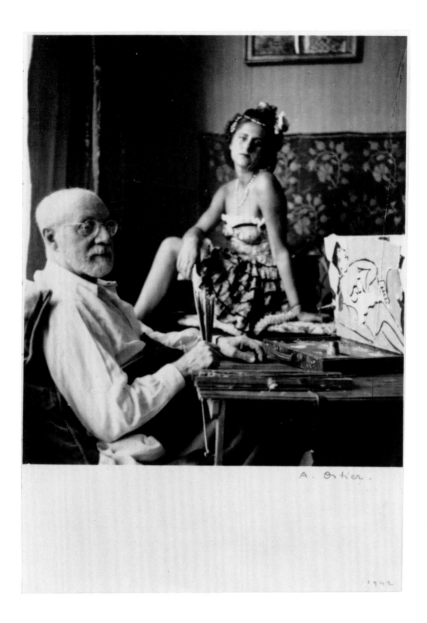

Matisse with a model, c. 1949–53.
The Pierre Matisse Gallery Archives.
The Pierpoint Morgan Library, New York,
MA 5020

Henri Matisse

was born in Le Cateau-Cambrésis, in northern France, in 1869. He did not discover art until age twenty, when, convalescing from acute appendicitis, he was given a paint box by his mother. "The moment I had this box of colors in my hands," he said later, "I had the feeling my life was there." He gave up a career in law, and in 1892 he moved to Paris to study art, successively exploring Dutch Old Master paintings, Impressionism, Paul Cézanne, and Neo-Impressionism. In 1905 Matisse found his artistic liberation; on a painting trip in southern France, he and artist André Derain developed a radical new approach to painting. Fauvism, as it would later be called, released color from the constraints of fixed contours, theoretical rules, and traditional representation; superseding drawing, it allowed color to define the structure of a painting. This innovation of pictorial construction through colored surfaces—a "return to the purity of means," Matisse said—was the source of everything that followed in his art.

Matisse remained the acknowledged leader of the Fauvist movement until its dissolution around 1908. Other Fauvists shifted toward Expressionism or Cubism or turned to tradition, but Matisse continued to explore pure color. His goal of producing "an art of balance, of purity and serenity" is evident in the peaceful sensuality of the interiors, landscapes, figures, and still lifes of his mature work. After five decades of work in painting, sculpture, drawing, graphic art, and printmaking, Matisse spent the last, extremely productive years of his life in Nice, on the French Riviera. He died in 1954, widely regarded as the greatest French painter the century had produced, a judgment that remains unchallenged almost sixty years later.

Produced by
The Department of Publications,
The Museum of Modern Art, New York

This publication is made possible by
the Dale S. and Norman Mills Leff
Publication Fund.

Edited by Rebecca Roberts
Designed by Amanda Washburn
Production by Elisa Frohlich

Printed and bound by Oceanic
Graphic Printing, Inc., China
Typeset in Avenir
Printed on 140 gsm Gold East Matte
Artpaper

Library of Congress Catalogue Card
Number: 2008921260
ISBN: 978-0-87070-724-7

Published by
The Museum of Modern Art
11 West 53 Street
New York, New York 10019-5497
www.moma.org

Distributed in the United States and
Canada by D.A.P./Distributed Art
Publishers, Inc., New York

Distributed outside the United States
and Canada by Thames & Hudson,
Ltd., London

Printed in China

Photograph Credits

All works of art by Henri Matisse
© 2008 Succession H. Matisse, Paris/
Artists Rights Society (ARS), New York

Hélène Adant: 37; Hélène Adant/
courtesy Bibliothèque Kandinsky: 36;
courtesy The Barnes Foundation: 10;
© 2008 Artists Rights Society (ARS),
New York/ADAGP, Paris: 5; Department
of Imaging Services, The Museum of
Modern Art, Thomas Griesel: 4, 12, 21,
24, 26 (left), Kate Keller: 17, 19, 23, 26
(center), 32, 35, 38–39, John Wronn: 7,
14, 27, 30 (all); courtesy The Metropolitan
Museum of Art, New York: 4, 5, 13 (left);
Philippe Migeat/© 2008 CNAC/MNAN/
Réunion des Musées Nationaux/Art
Resource, New York: 18 (right); Moderna
Museet, Stockholm: 15 (left); The Board
of Trustees, National Gallery of Art,
Washington: 15 (right); Jean-Claude
Planchet/© 2008 CNAC/MNAM/
Réunion des Musées Nationaux/Art
Resource, New York: 18 (left); The
Pierpoint Morgan Library/Art Resource,
New York; Scala, Florence/courtesy
The Ministero Beni e Att. Culturali,
Italy: 33 (left); SMK Photo: 13 (right);
Lee Stalsworth: 11; The State Hermitage
Museum: 7, 8–9; Adolph Studly: 28–29.

Trustees of The Museum of Modern Art

48